Find Your Zen With Color Me EVIE ART

CREATED AND DESIGNED BY
EVIE MARIE
EVIE-ART.COM

Copyright © 2016 Evie Marie

All rights reserved. No part of this publication may be reproduced, distributed, or transmitted in any form or by any means, including photocopying, recording, or other electronic or mechanical methods, without the prior written permission of Evie Marie, except in the case of thumbnails embodied in critical reviews and certain other noncommercial uses permitted by copyright law. For permission requests, contact Evie Marie at:

Evie-Art.com

Printed in the United States of America

NOTE from ARTIST

The one thing I love the most about art is there is no right and no wrong. It is what is perceived by the artist at that very moment. On another day, that perception could yield a completely different result. So exciting.

I invite you to join in this fun and encourage you to release your inner artist! I would be honored if you would add your personal touch to these drawings inspired from my heart. If you are so inclined, please share them with me.

You can do so by visiting **http://Evie-Art.com**. You can choose to share your artwork publicly on your favorite social media platform (or connect with me privately). Whatever you choose to do, I hope you find your Zen the way I did when drawing them.

Remember, there is absolutely no right and no wrong. Color it classic, be creative or be crazy! It's all about capturing this very moment, and the only thing that matters is the reality through your eyes. So if your inner voice says this waterfall needs to be neon pink, by all means, embrace the moment!

XOXOXO,

Evie Marie

Find Your Zen with Evie Art Evie-Art.com

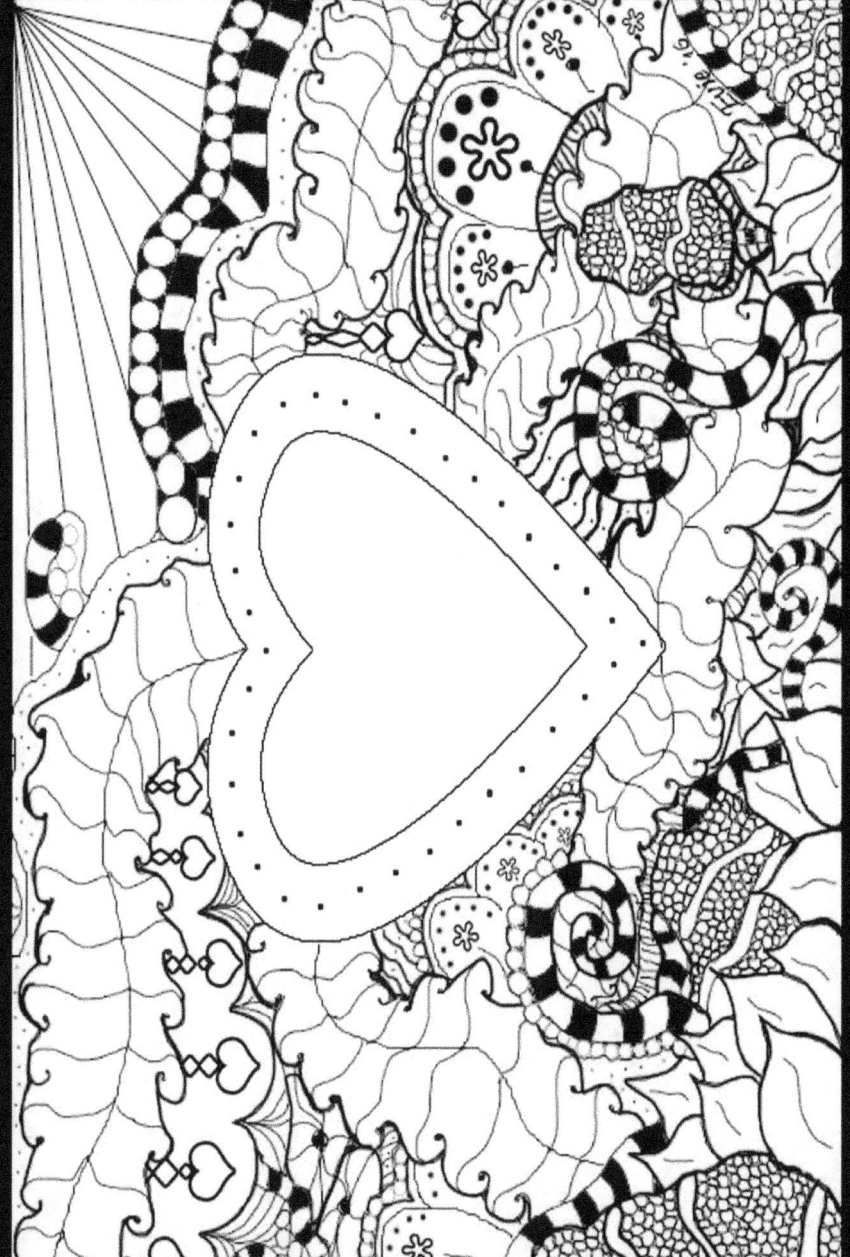

Find Your Zen with Evie Art **Evie-Art.com**

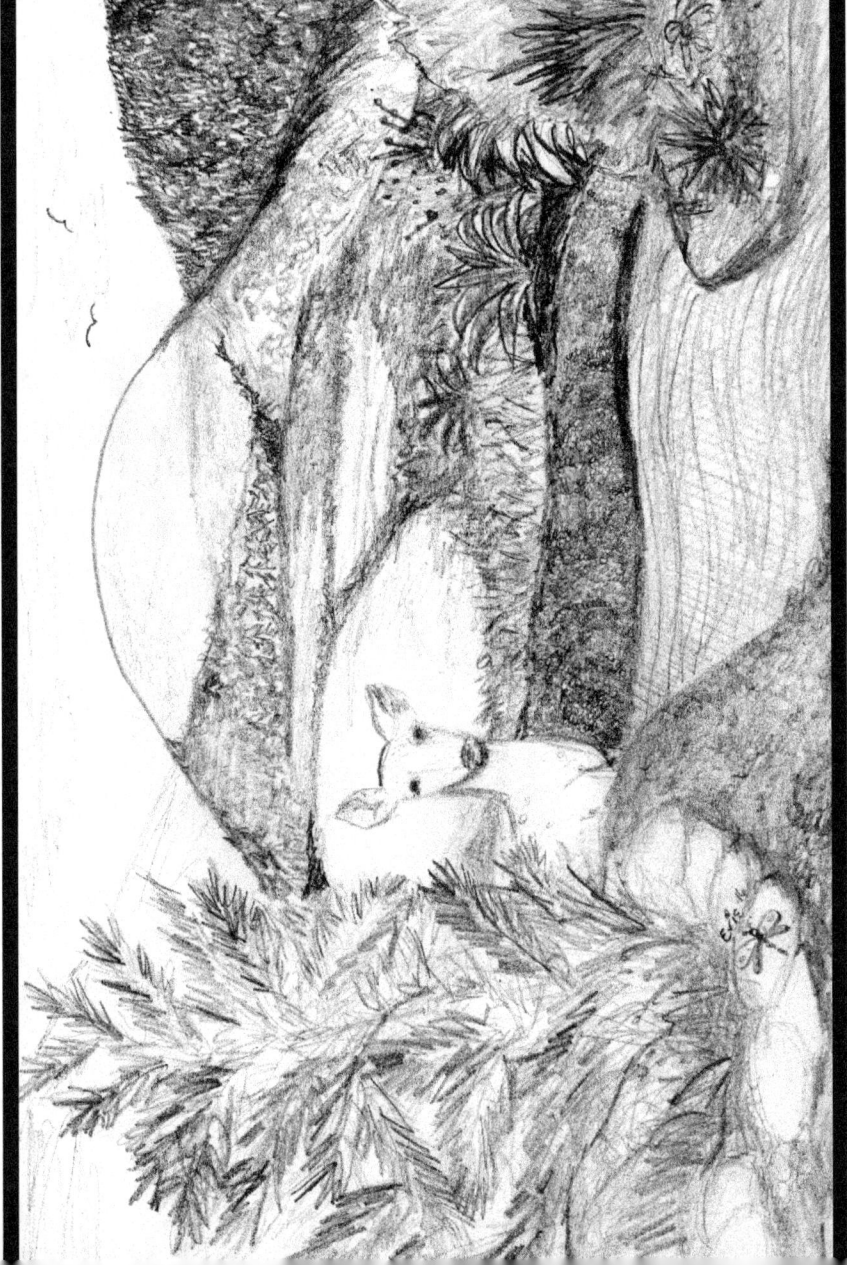

Find Your Zen with Evie Art Evie-Art.com

Find Your Zen with Evie Art Evie-Art.com

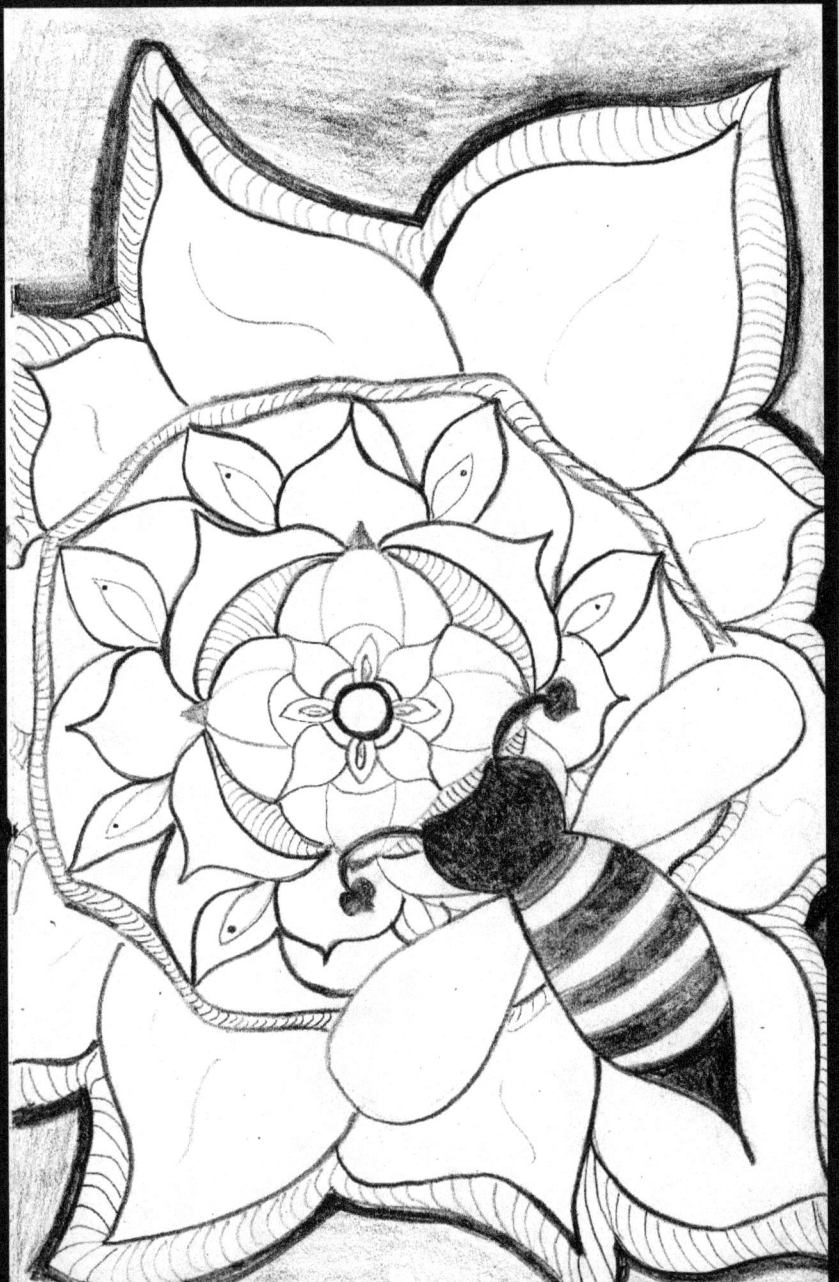

Find Your Zen with Evie Art Evie-Art.com

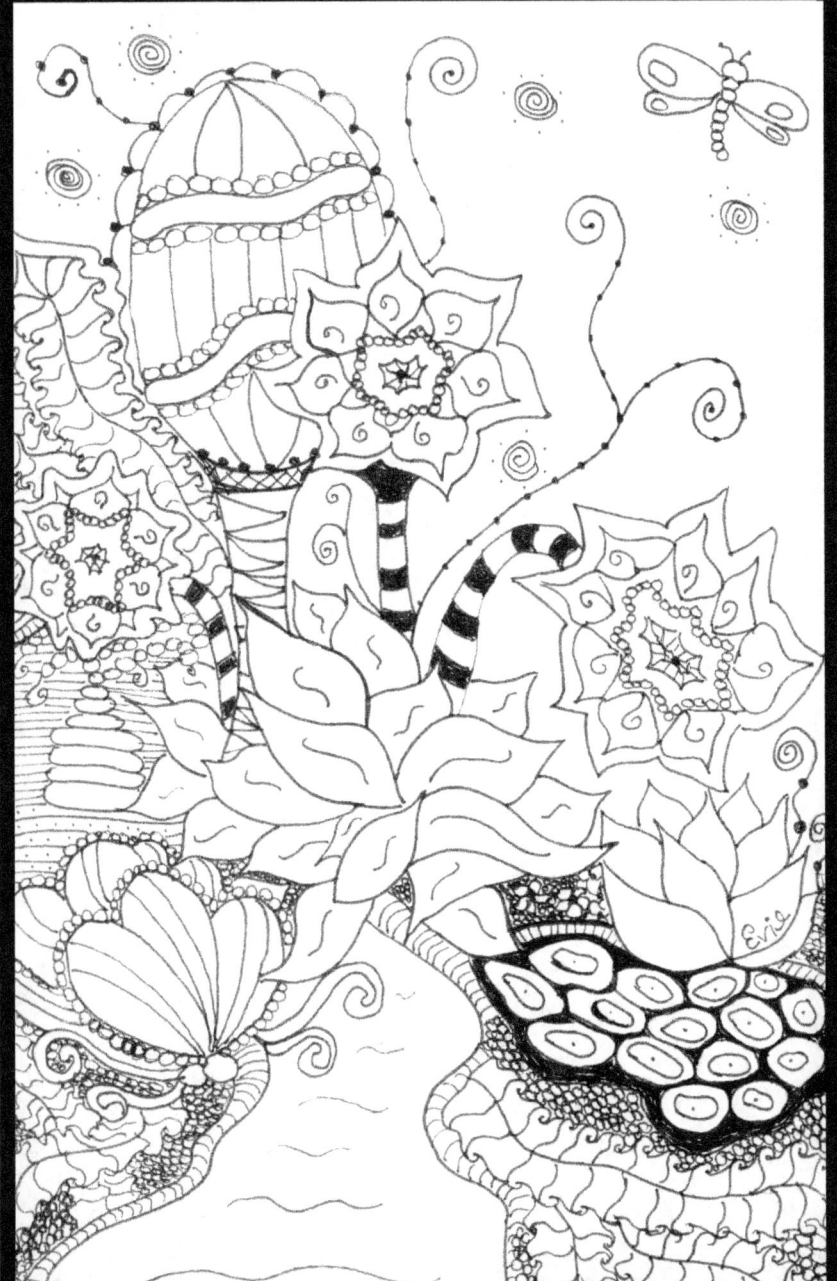

Find Your Zen with Evie Art Evie-Art.com

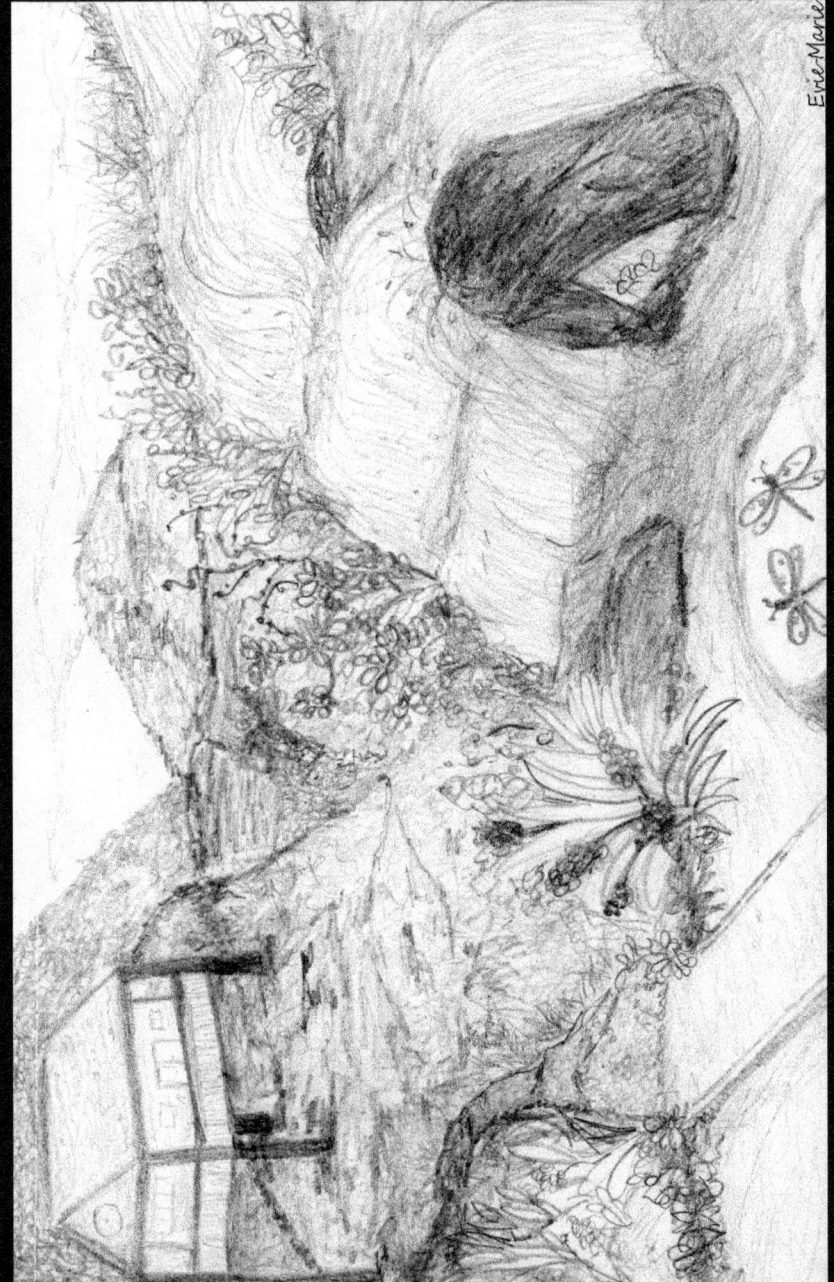

Find Your Zen with Evie Art Evie-Art.com

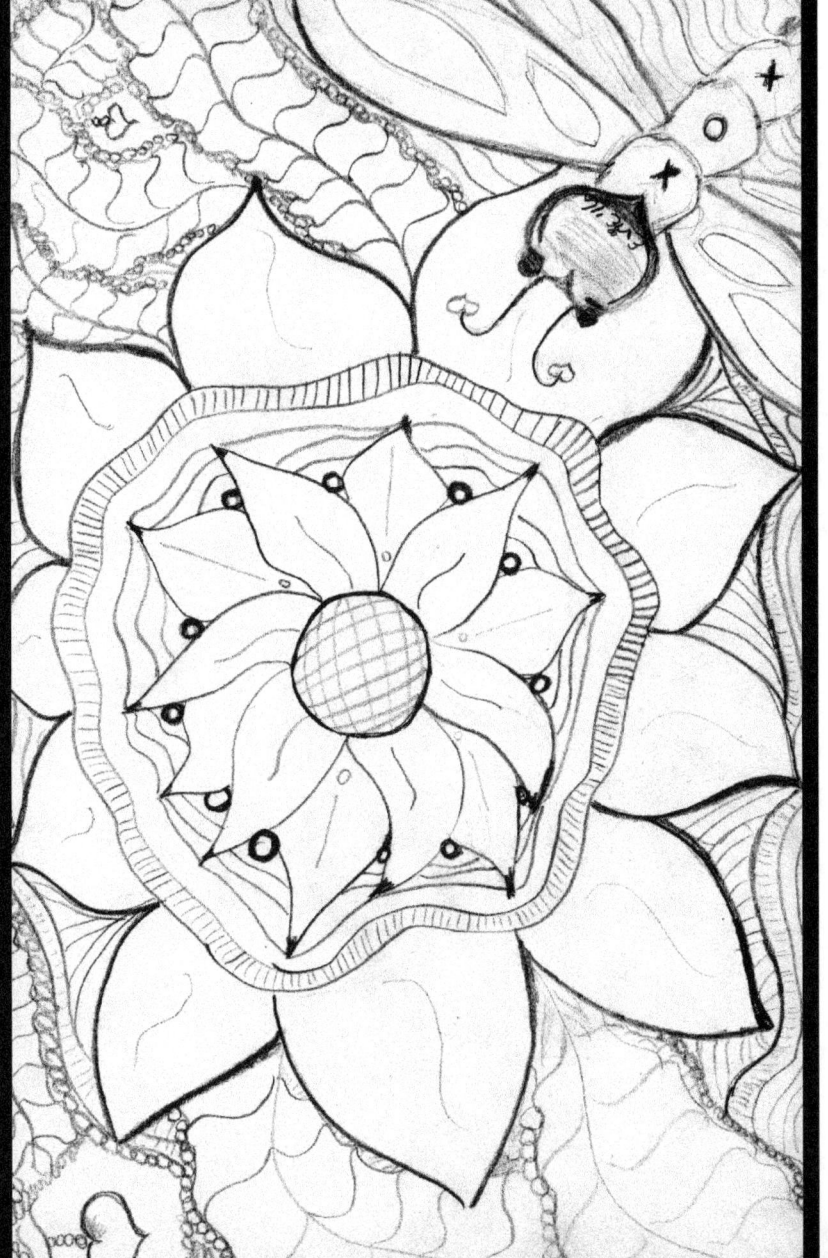

Find Your Zen with Evie Art Evie-Art.com

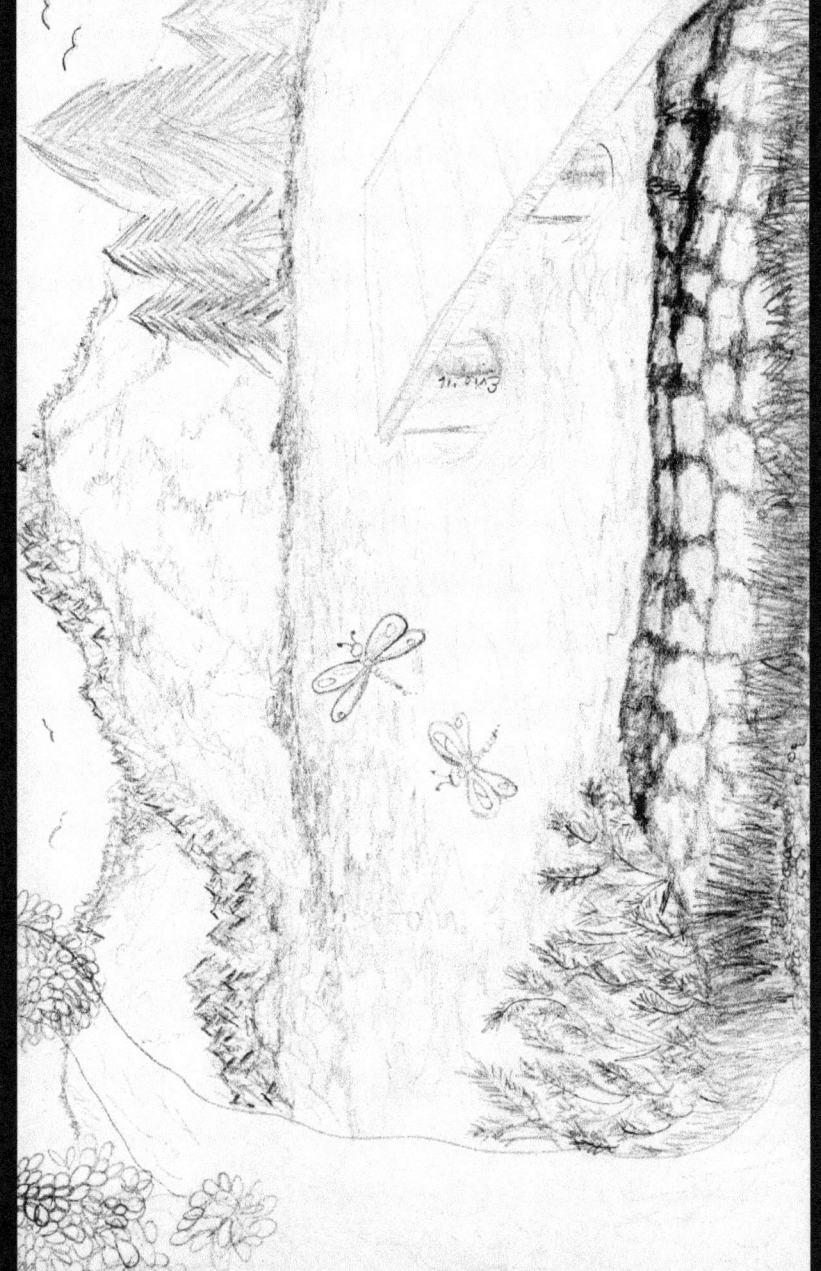

Find Your Zen with Evie Art Evie-Art.com

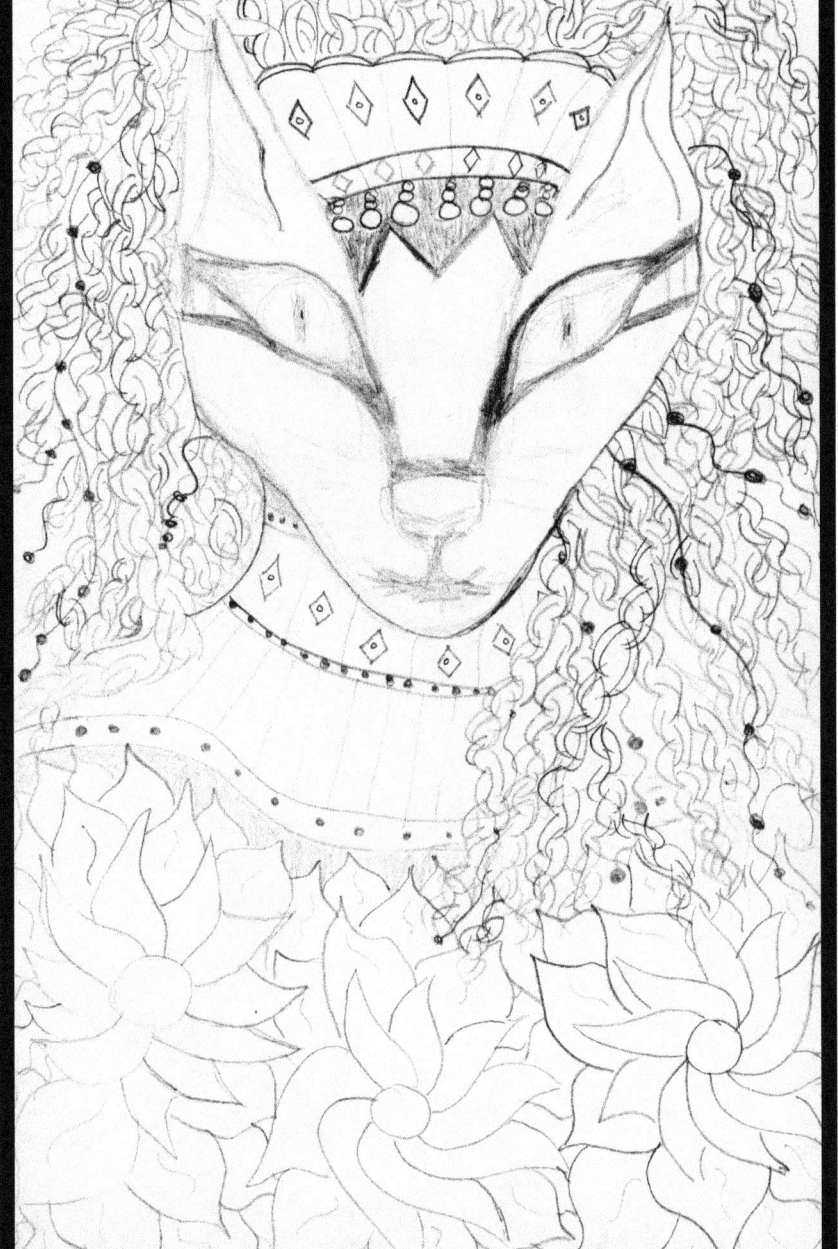

Find Your Zen with Evie Art Evie-Art.com

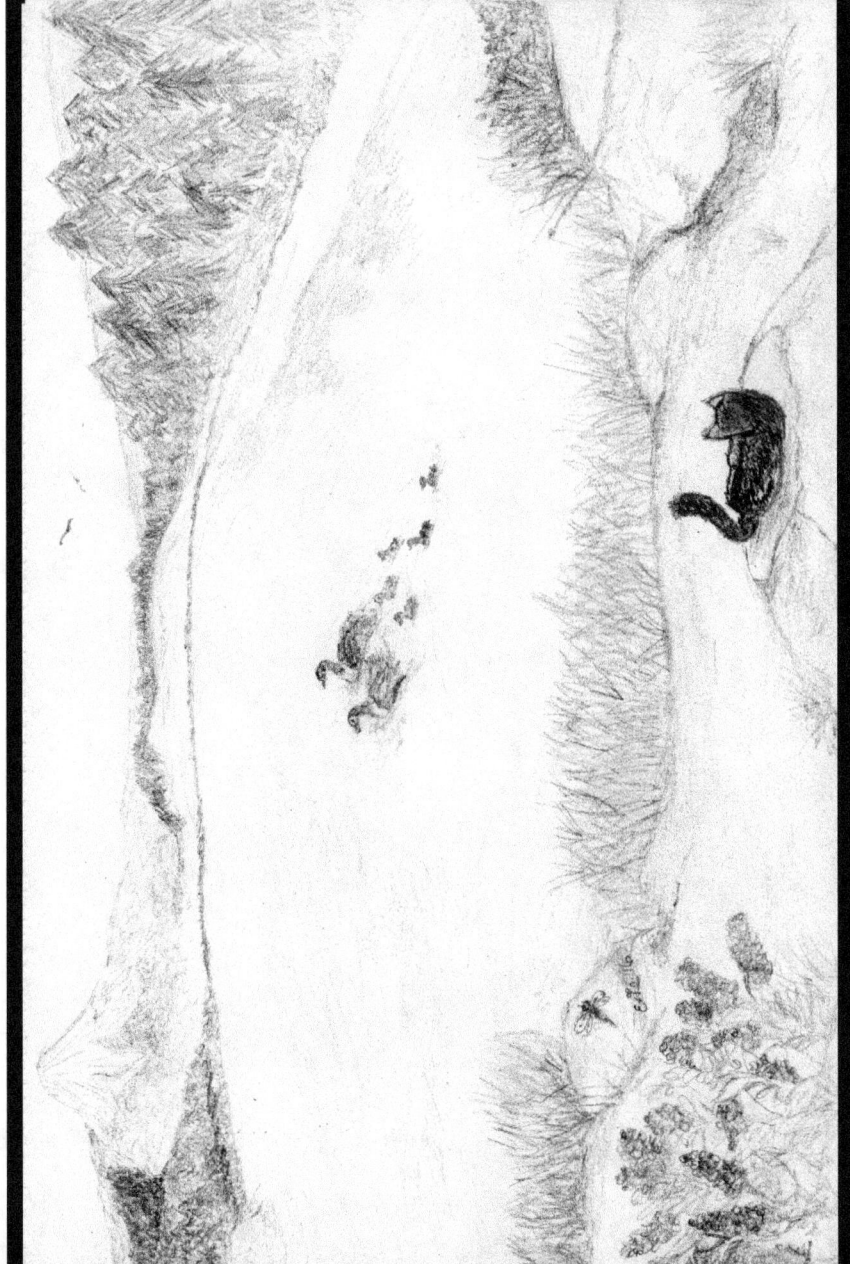

Find Your Zen with Evie Art Evie-Art.com

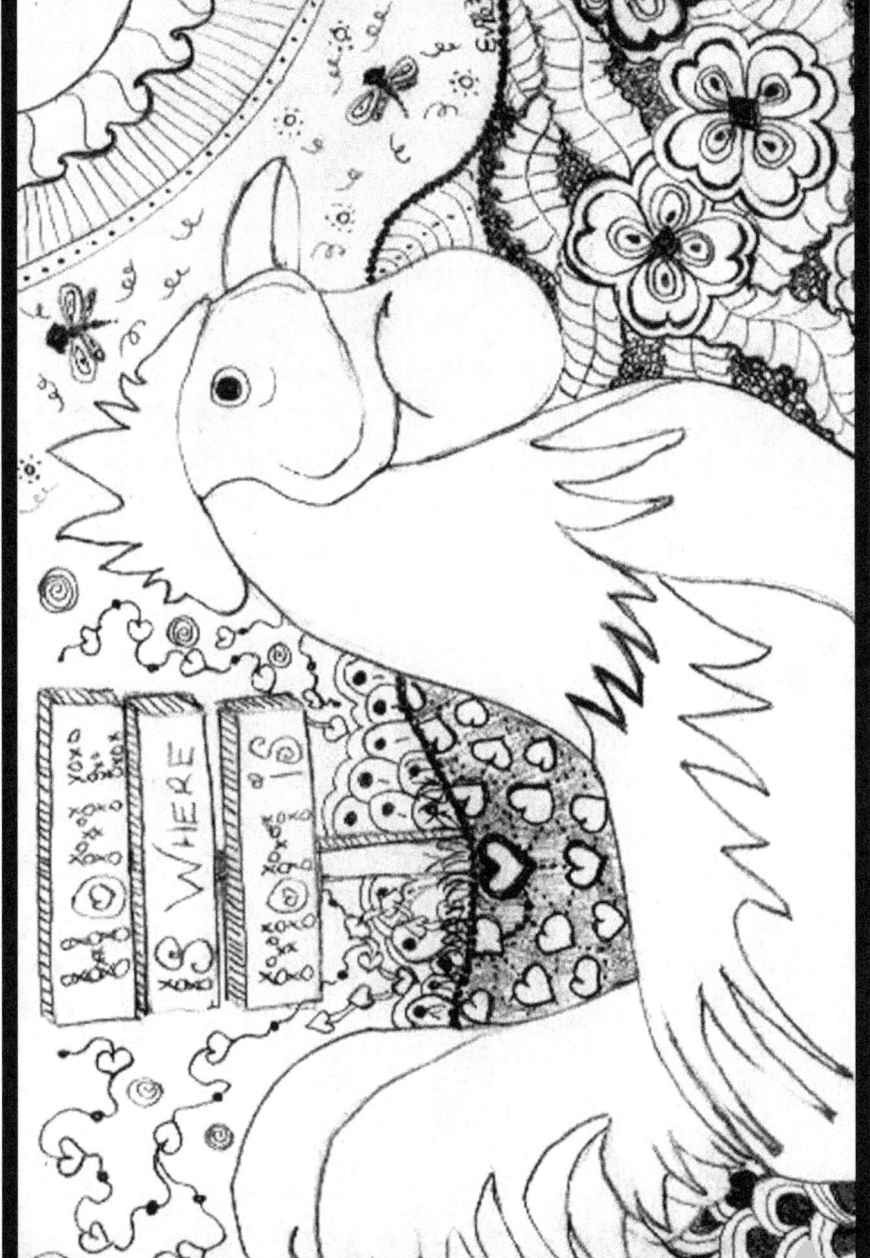

Find Your Zen with Evie ArtEvie-Art.com

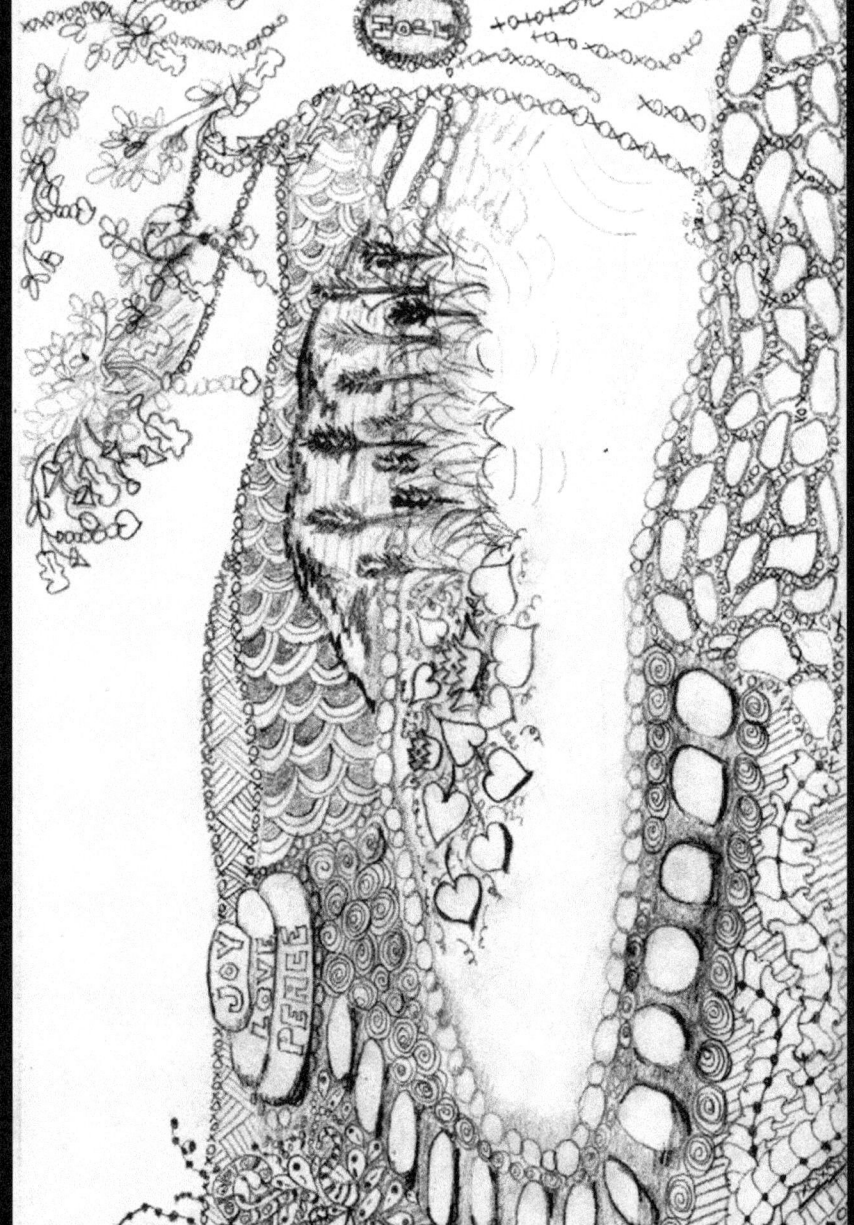

Find Your Zen with Evie Art Evie-Art.com

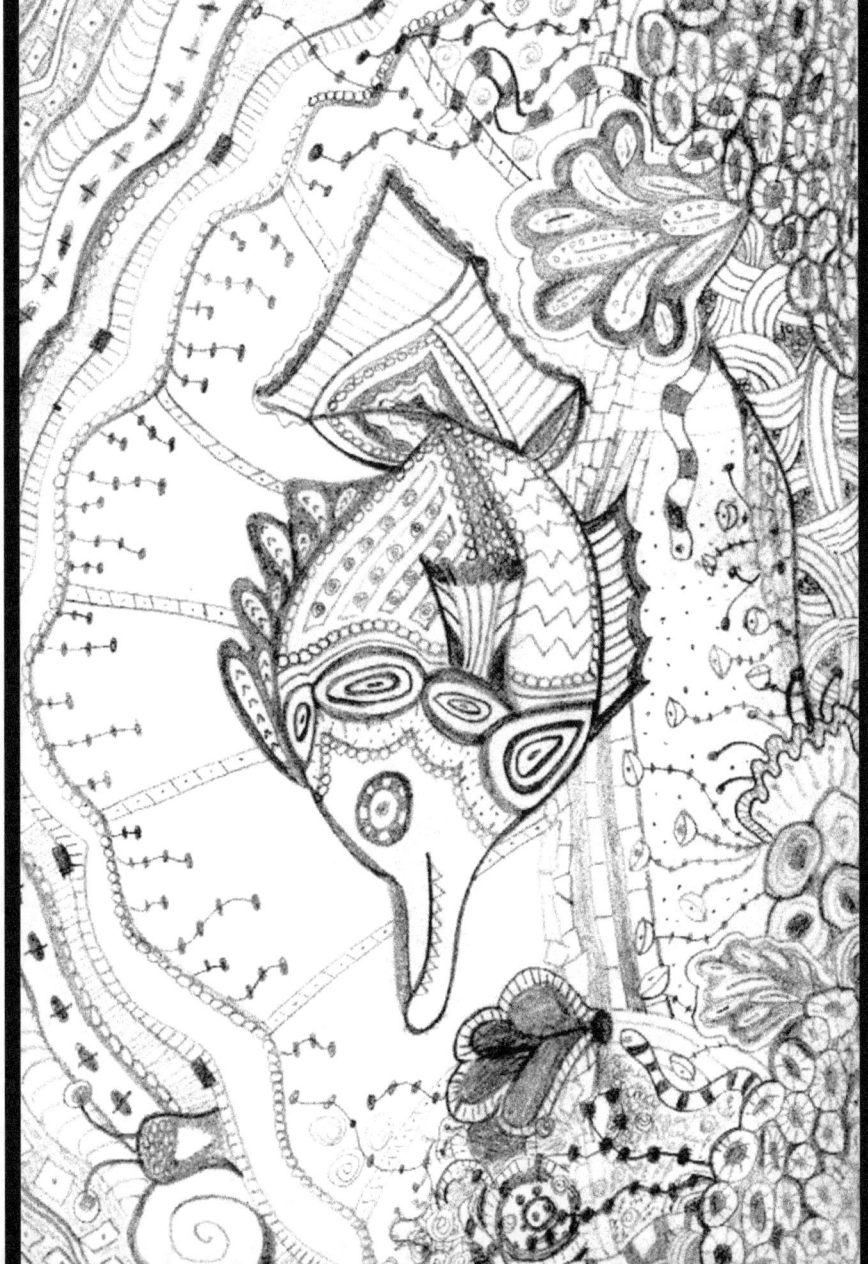

Find Your Zen with Evie Art Evie-Art.com

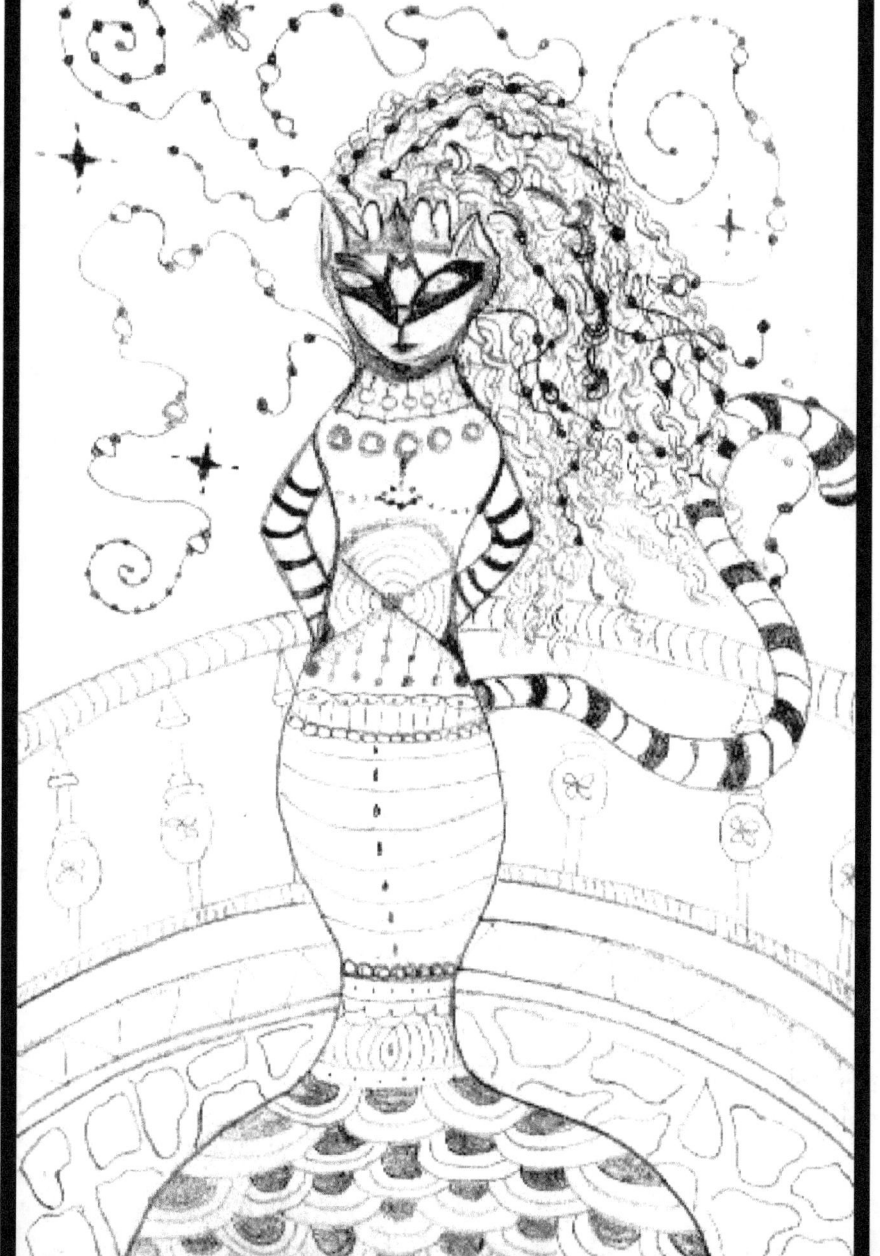

Find Your Zen with Evie Art Evie-Art.com

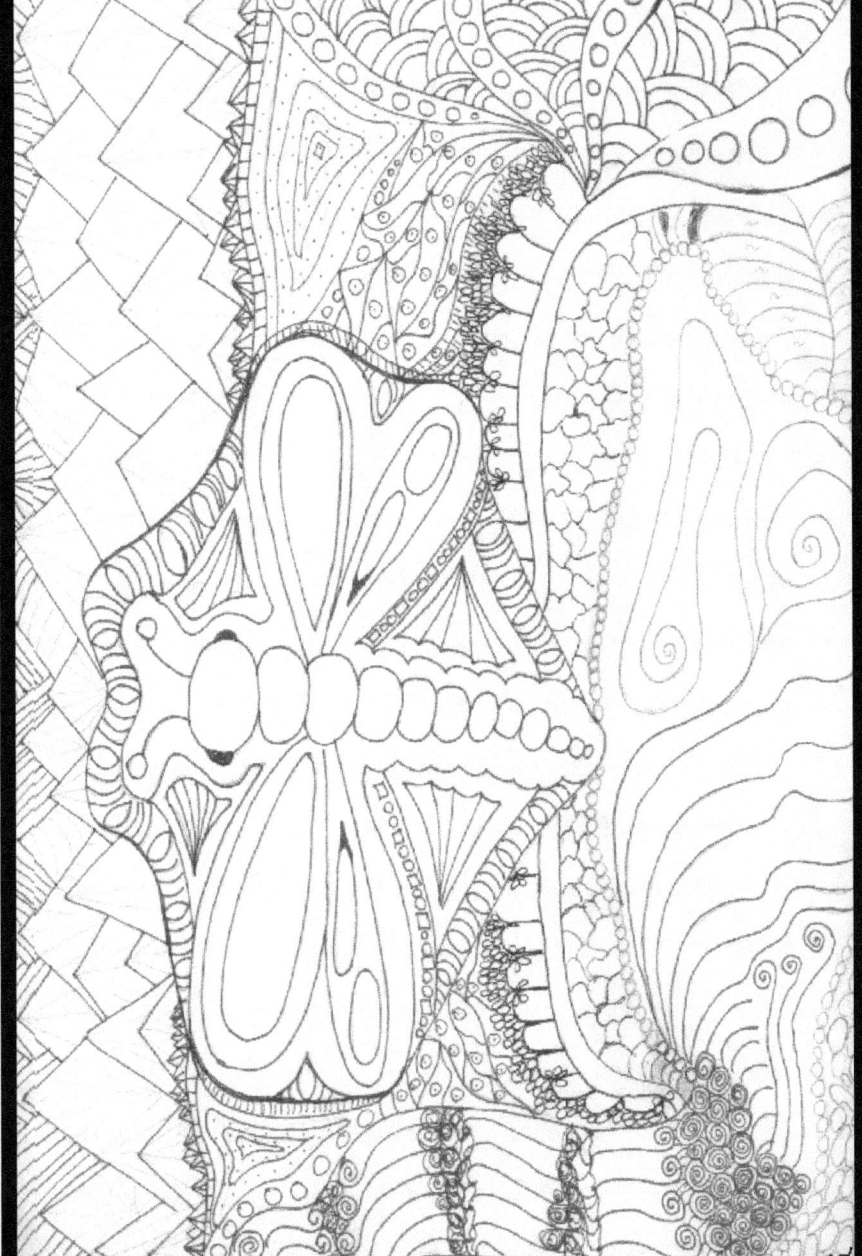

Find Your Zen with Evie Art Evie-Art.com

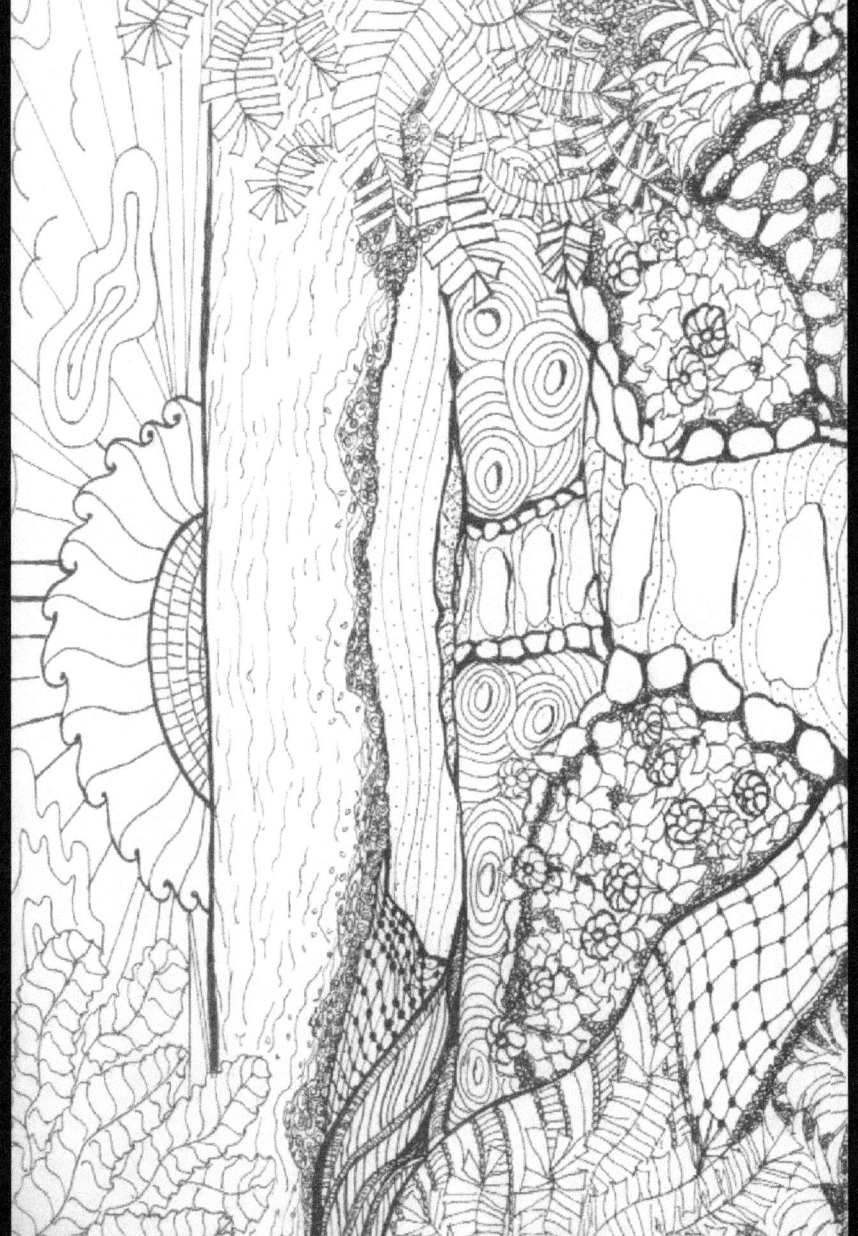

Find Your Zen with Evie Art　　　　　　　　Evie-Art.com

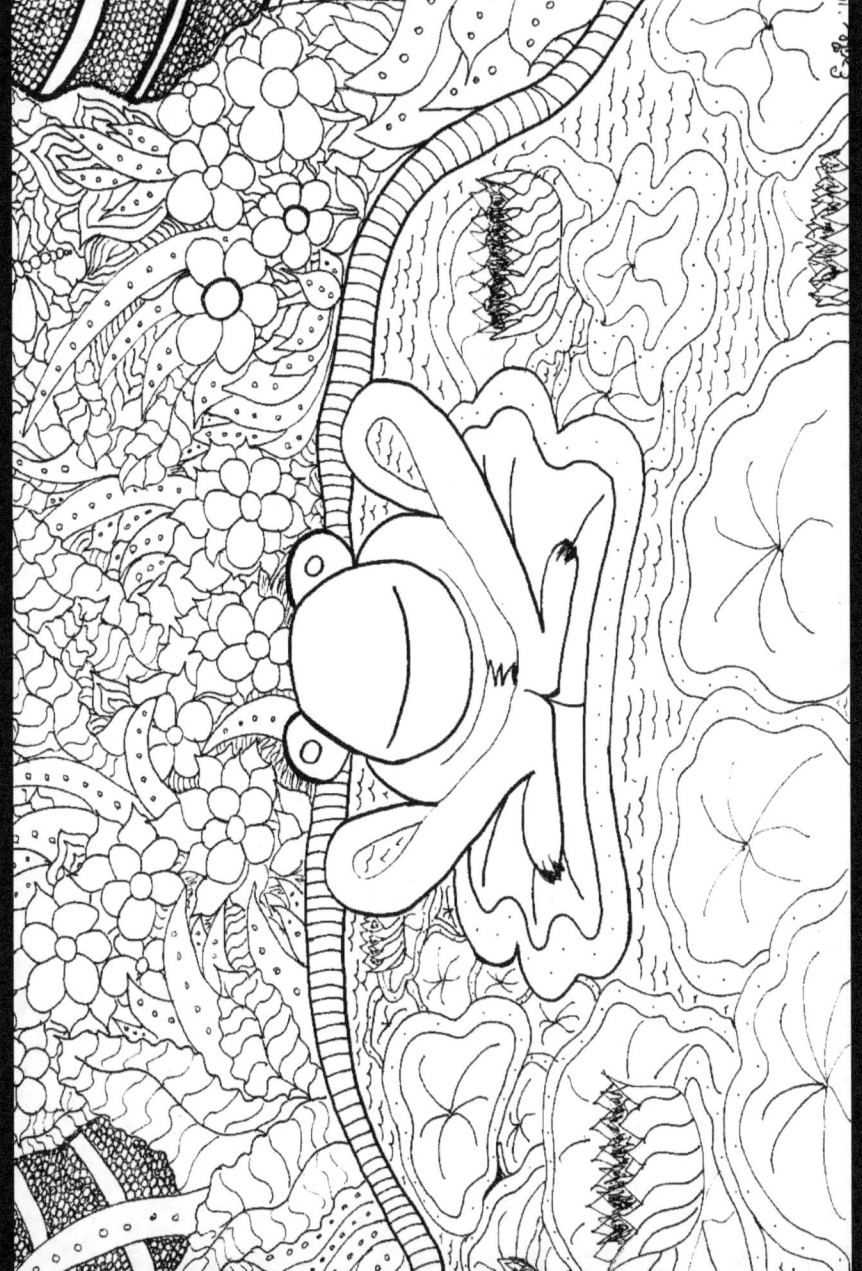

Find Your Zen with Evie Art Evie-Art.com

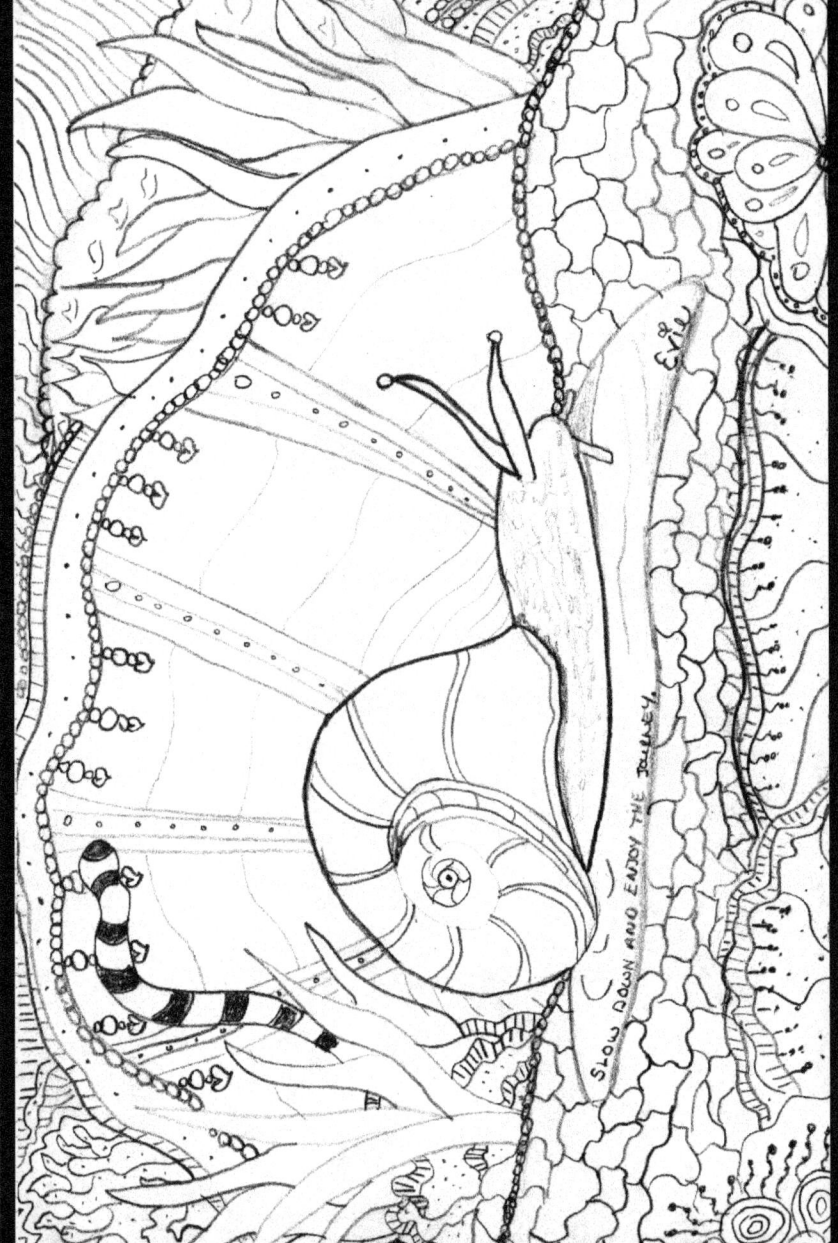

Find Your Zen with Evie Art Evie-Art.com

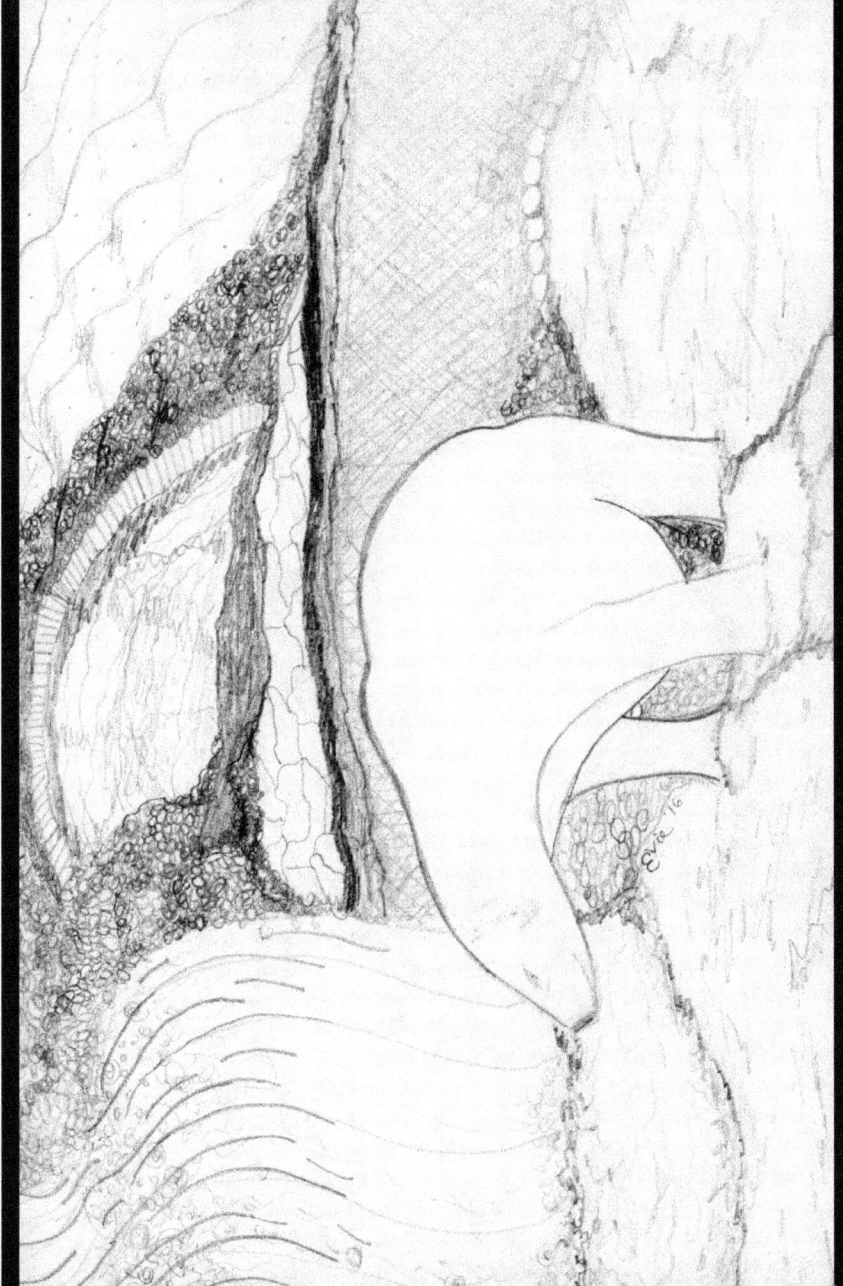

Find Your Zen with Evie Art Evie-Art.com

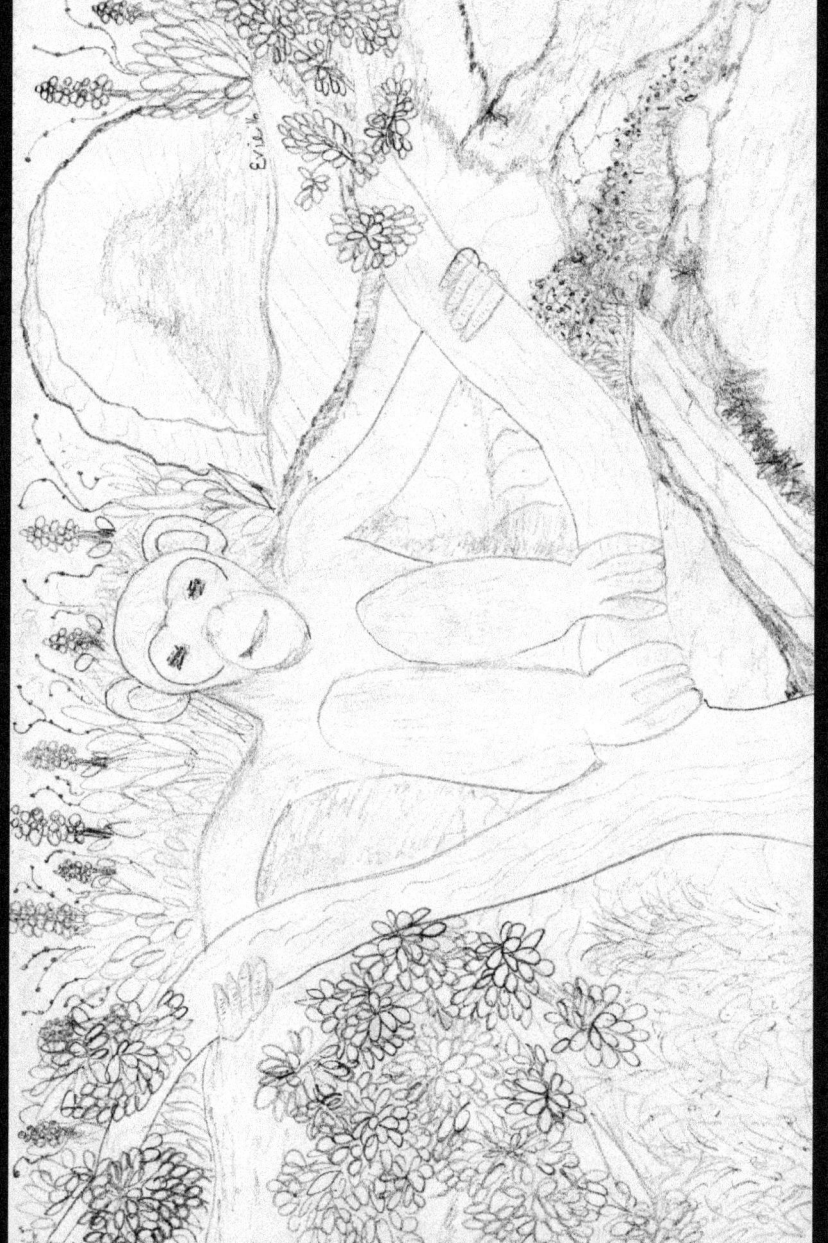

Find Your Zen with Evie Art Evie-Art.com

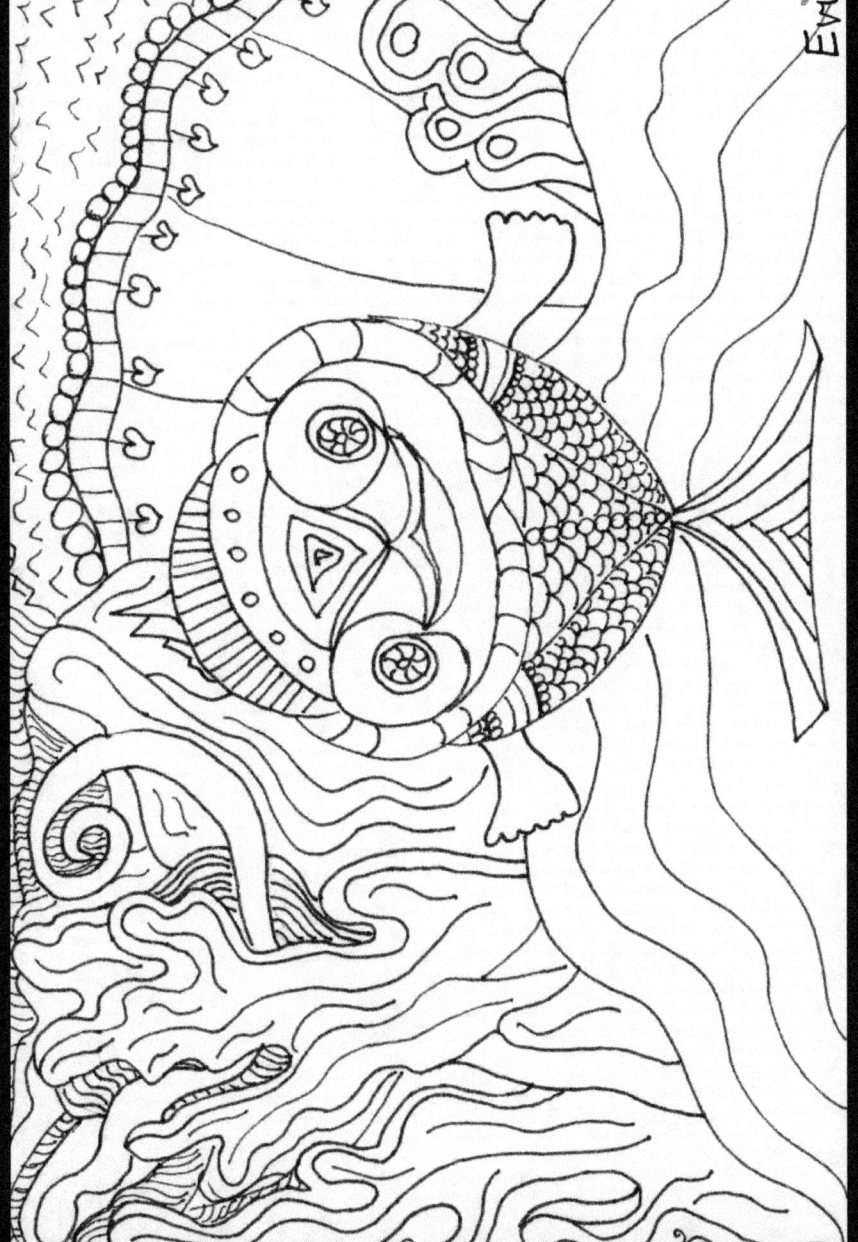

Find Your Zen with Evie Art Evie-Art.com

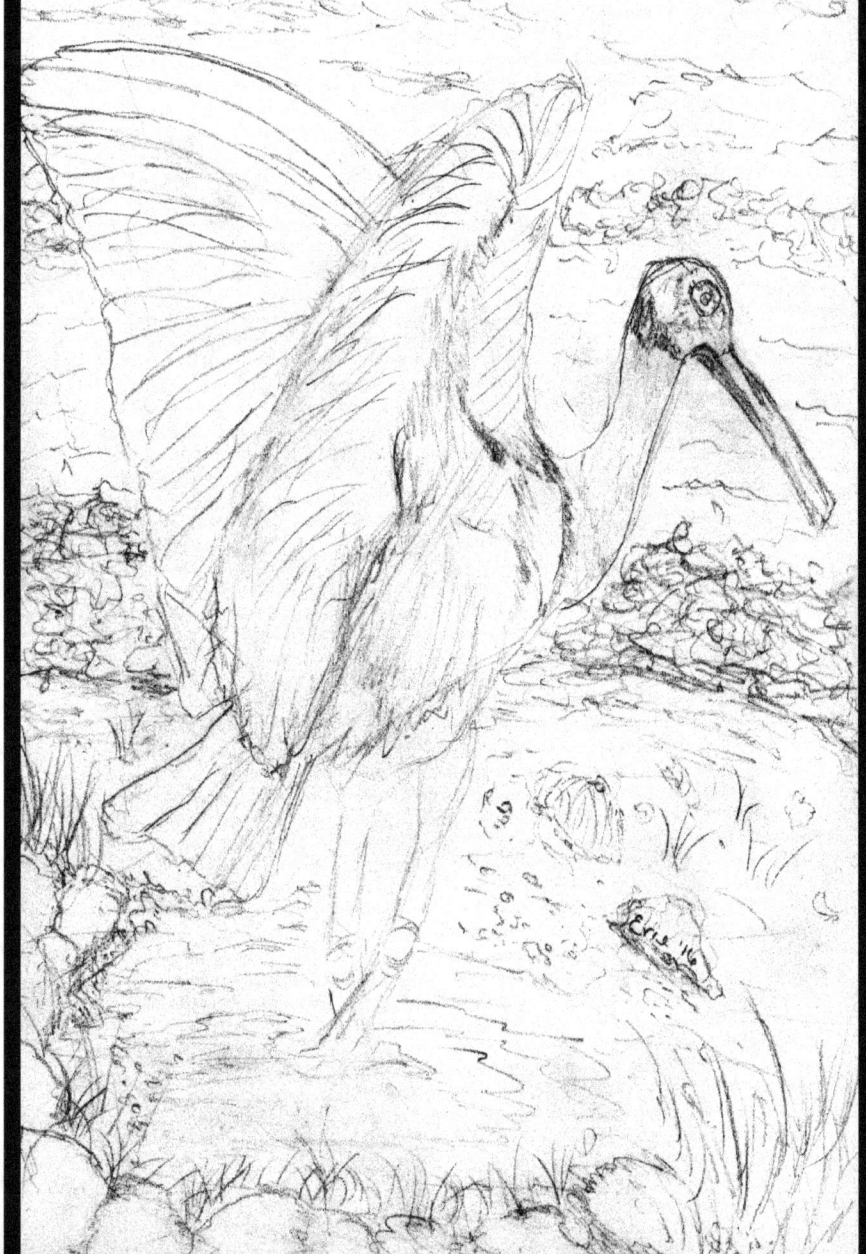

Find Your Zen with Evie Art Evie-Art.com

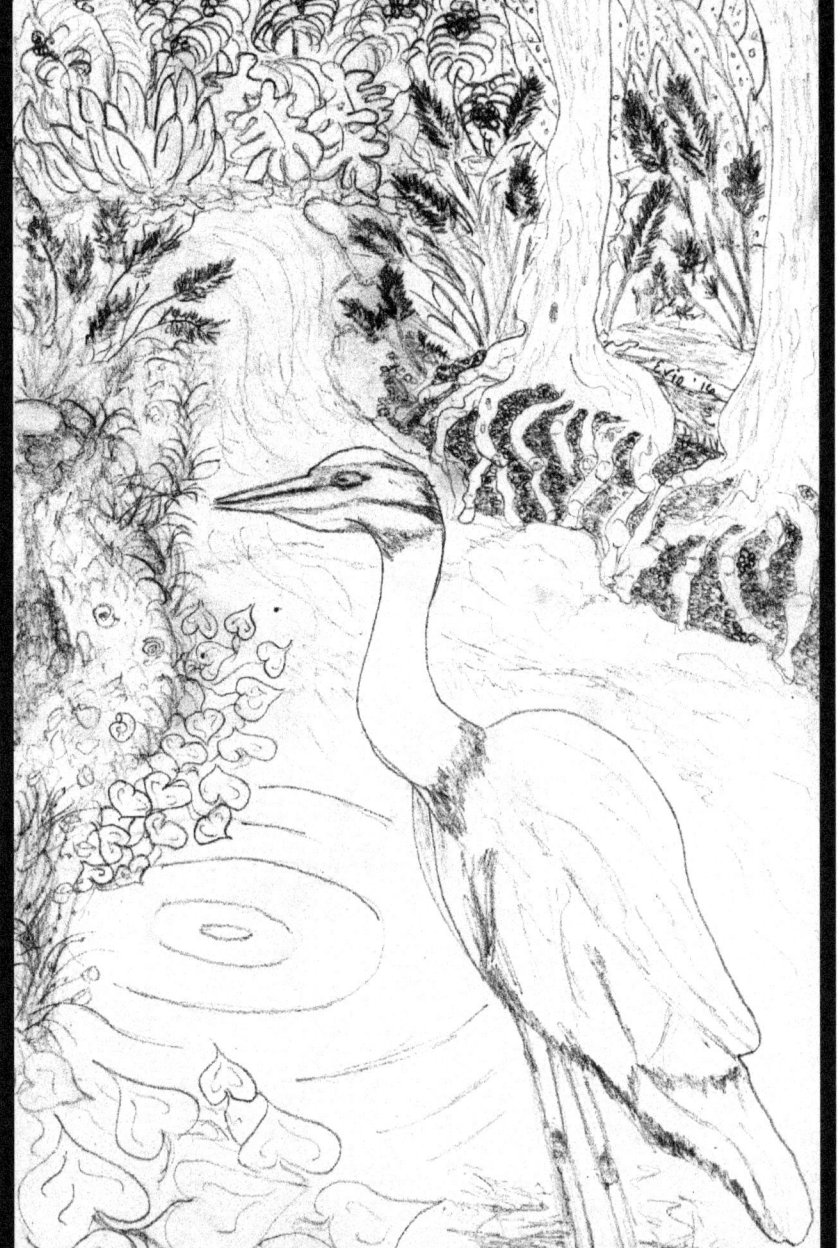

Find Your Zen with Evie Art Evie-Art.com

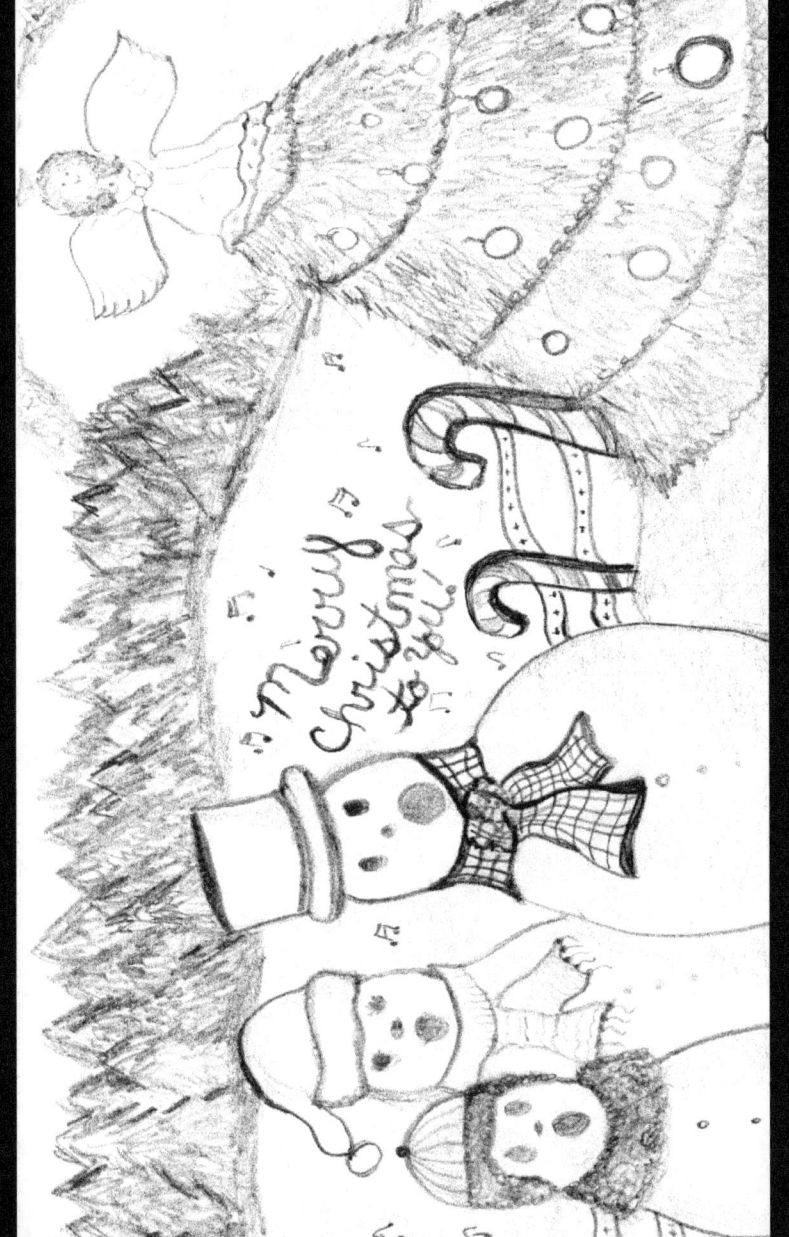

Find Your Zen with Evie Art Evie-Art.com

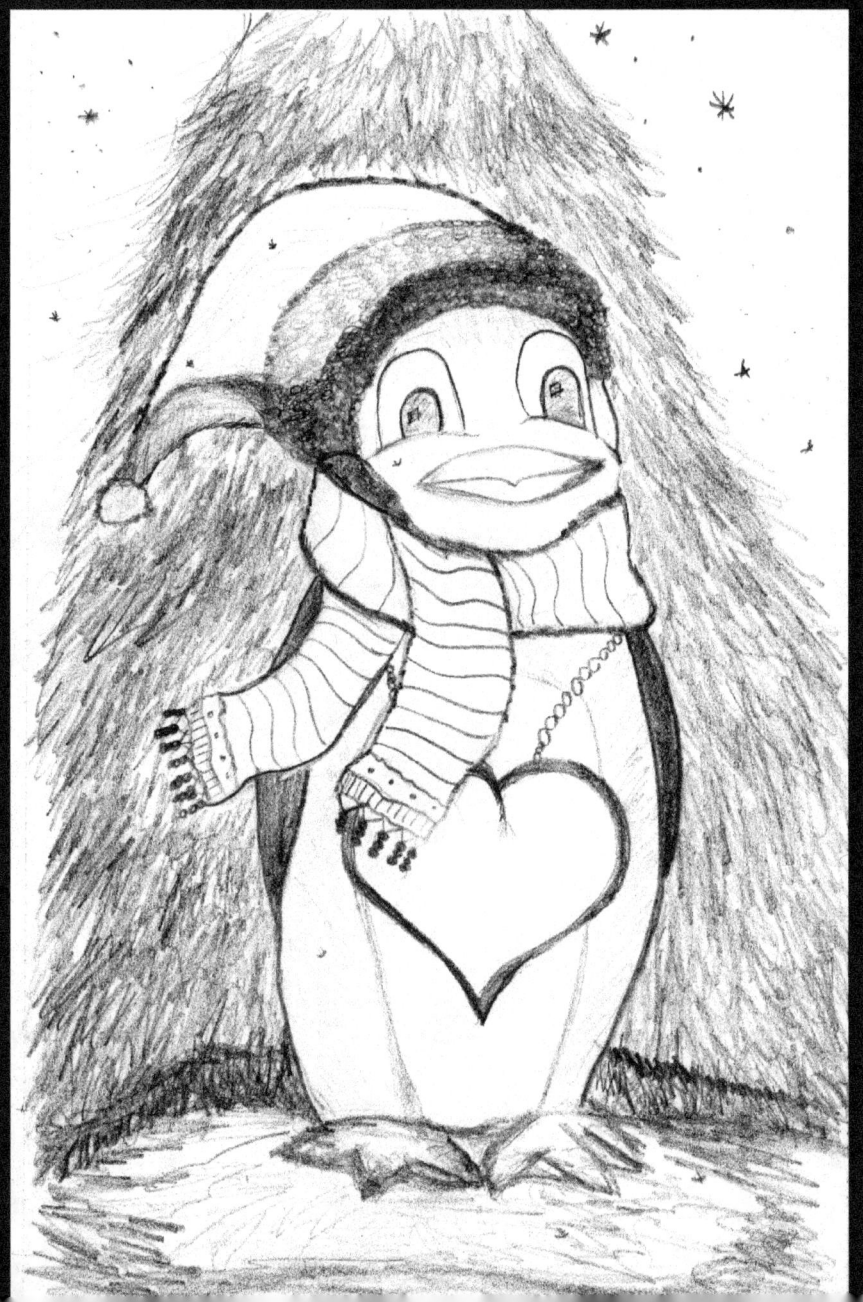

Find Your Zen with Evie Art Evie-Art.com

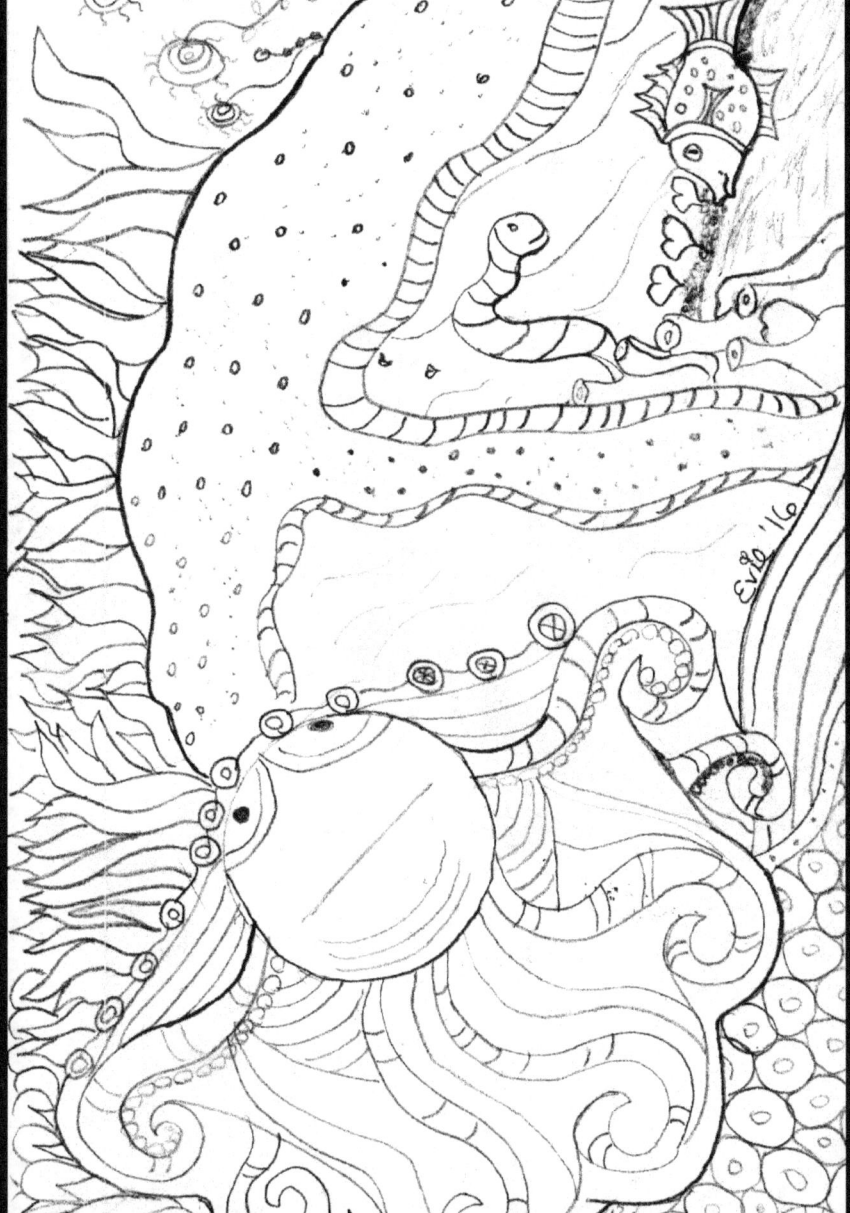

Find Your Zen with Evie Art Evie-Art.com

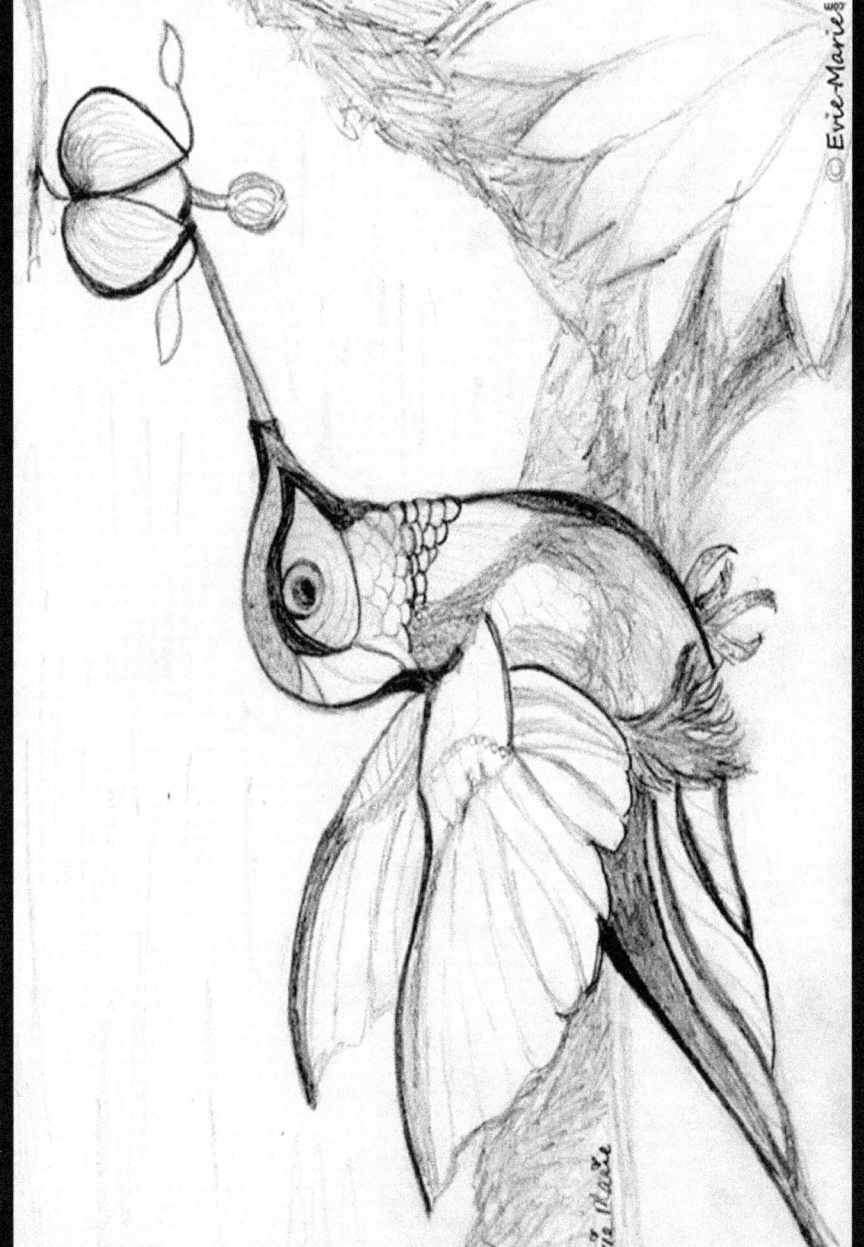

Find Your Zen with Evie Art Evie-Art.com

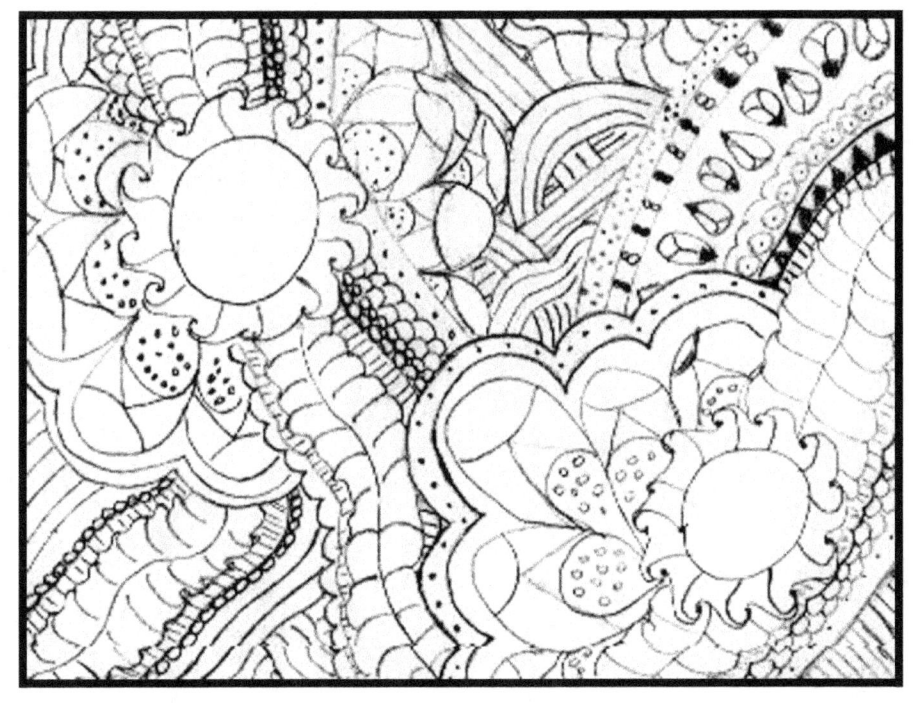

HOPE YOU FOUND YOUR ZEN!

Don't forget to share your wonderful creations, if you are so inclined, by visiting Evie-Art.com